How to Draw

Sea Creatures

In simple steps

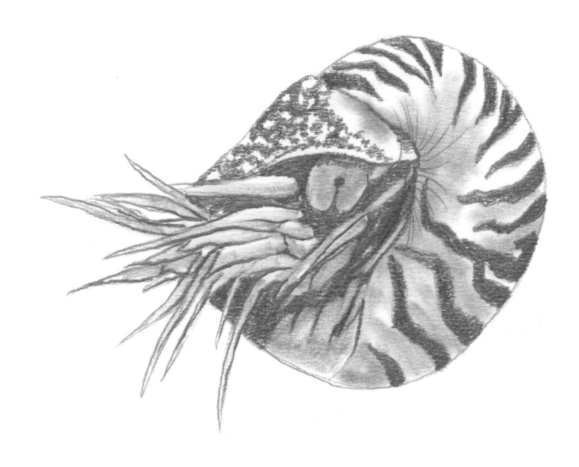

First published in 2023

Search Press Limited
Wellwood, North Farm Road,
Tunbridge Wells, Kent TN2 3DR

Text and illustrations copyright © Jonathan Newey, 2023

Design copyright © Search Press Ltd. 2023

ISBN: 978-1-80092-101-6
ebook ISBN: 978-1-80093-092-6

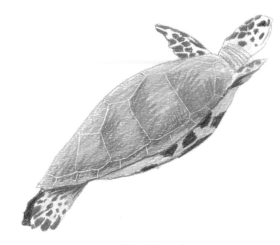

Dedication

*To my wife, Charlotte, and my family and friends and to
the wildlife of the world; you inspire me always.*

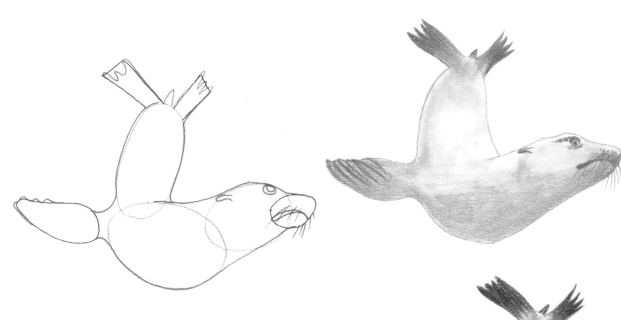

Illustrations

How to Draw

Sea Creatures

In simple steps

Jonathan Newey

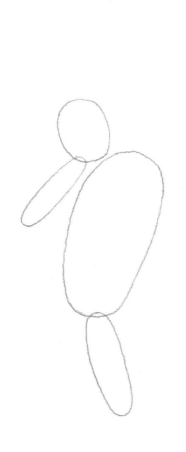
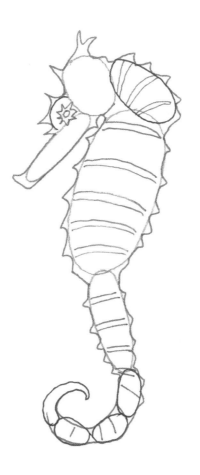
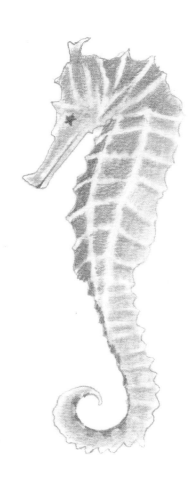

Search Press

Introduction

This book introduces you to drawing all kinds of sea creatures. Using step-by-step techniques, it explains how to build up the form of each animal using basic shapes and lines. I have included a variety of sea creatures in various poses, including illustrations of fish, mammals and crustaceans.

Each project begins with basic shapes drawn in graphite pencil. New lines are added for each subsequent step and these have been drawn in brown pencil to differentiate them from the initial graphite steps, which are left in as a guide. When making your own pencil marks, make sure they are all easily erased at the end of the drawing stages before starting the shading or colouring in.

At the bottom of each page are two finished illustrations, one drawn in graphite pencil and the other using coloured pencils. The black and white drawing shows the form and texture, which are not easily visible in coloured drawings. When you have finished your initial drawing and you are happy with the shapes and lines, then you can finish your project with the medium of your choice. All of the initial line drawing stages can be used as a basis for most drawing and painting media.

Try out as many of the projects as possible and in a variety of media. If you prefer to draw from your own source material, you may want to use photographs for reference or even do a picture of your pet from life if they can sit still long enough! Other sources for subjects are zoos and wildlife parks. A visit to the local library or surfing the internet can provide you with further reference, but remember that if you want to draw from someone else's photograph, you will need their permission or you may be in breach of copyright laws.

To gain further knowledge and for more inspiration, look at the work of other artists: David Shepherd, Robert Bateman, Alan Hunt and Terry Isaac are a few of my favourites. Practise as much as you can. Once you have gained enough experience and knowledge from the exercises in this book, spend time drawing as many different types of animal as you can. Each animal is different. Even the male and female of the same species can be quite different. The step-by-step method used in the demonstrations in this book can be used whichever animal you are trying to draw.

Finally, use this book as inspiration to practise your observational skills. Drawing correctly is all about using your eyes. Draw what you can see, not what you think is there, and, above all, enjoy yourself!

Happy drawing!

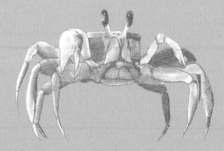

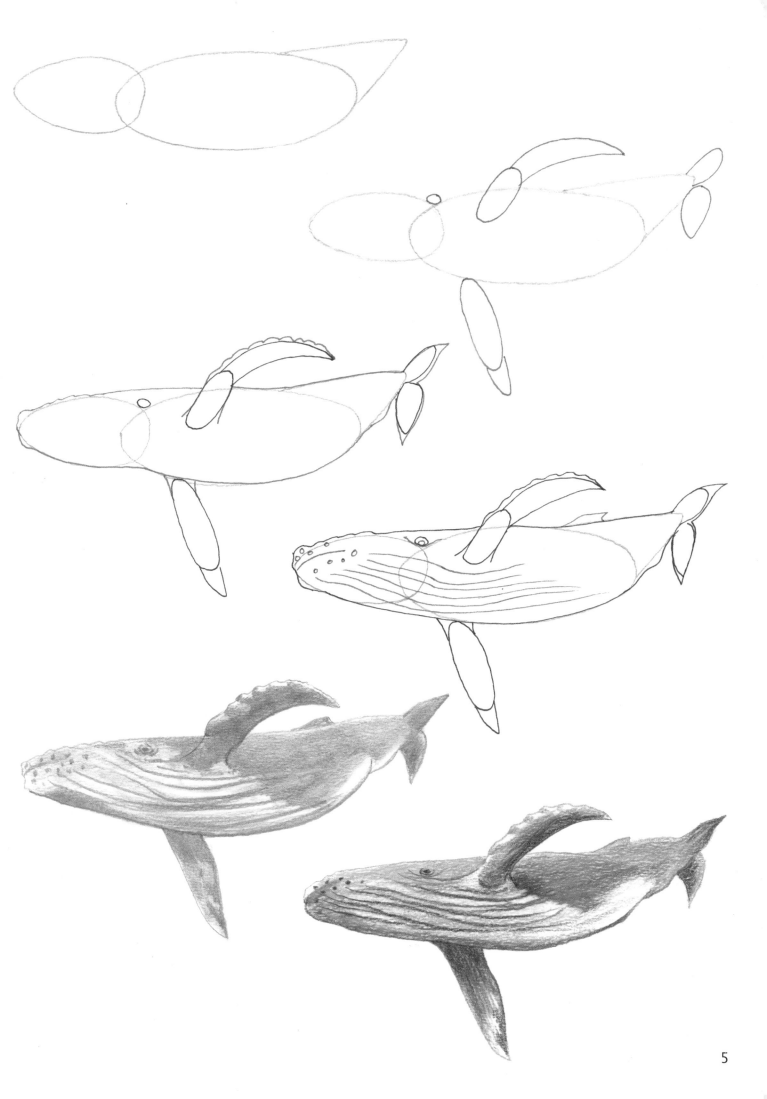

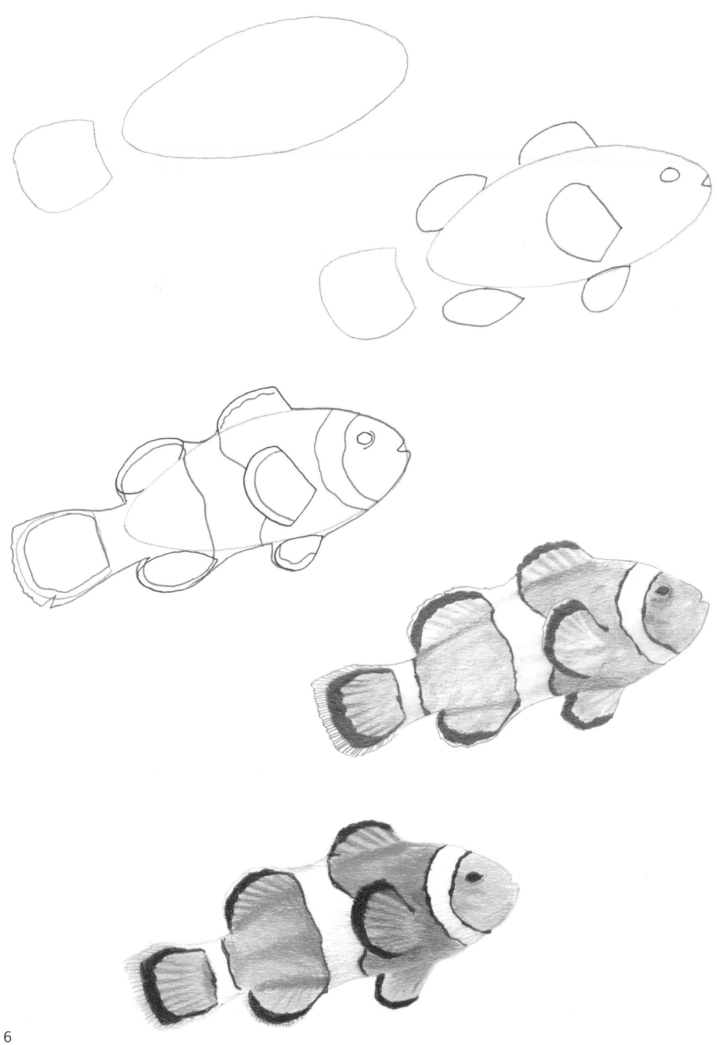

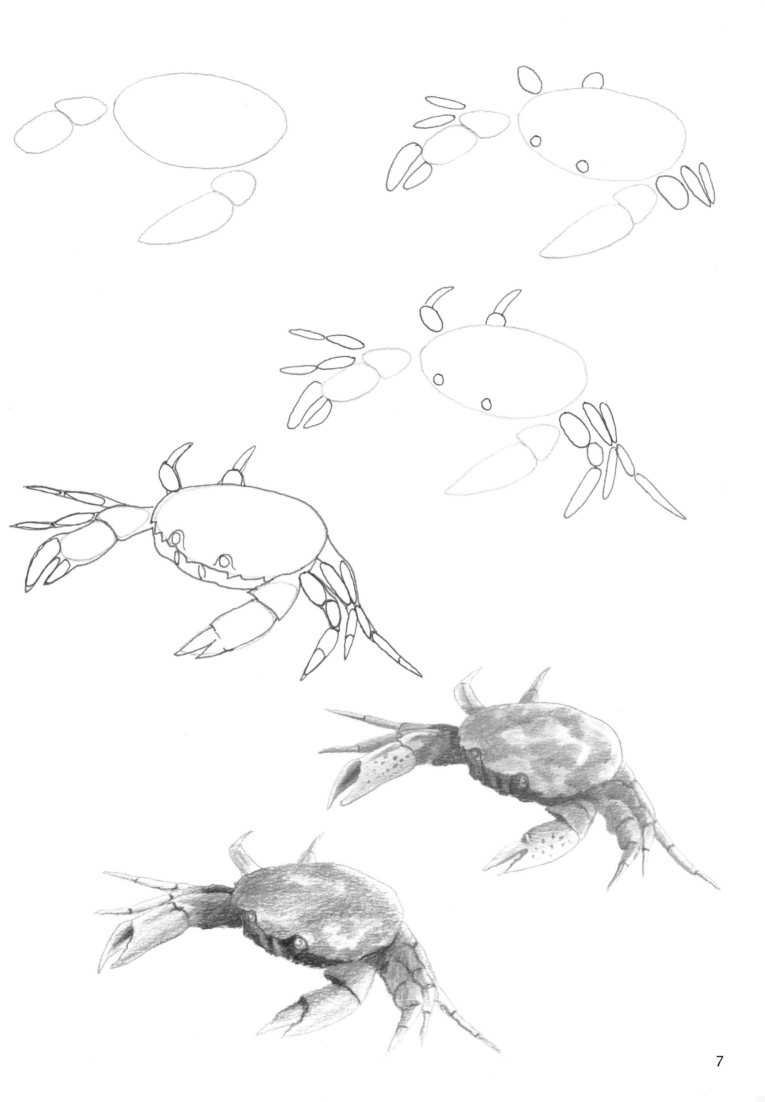

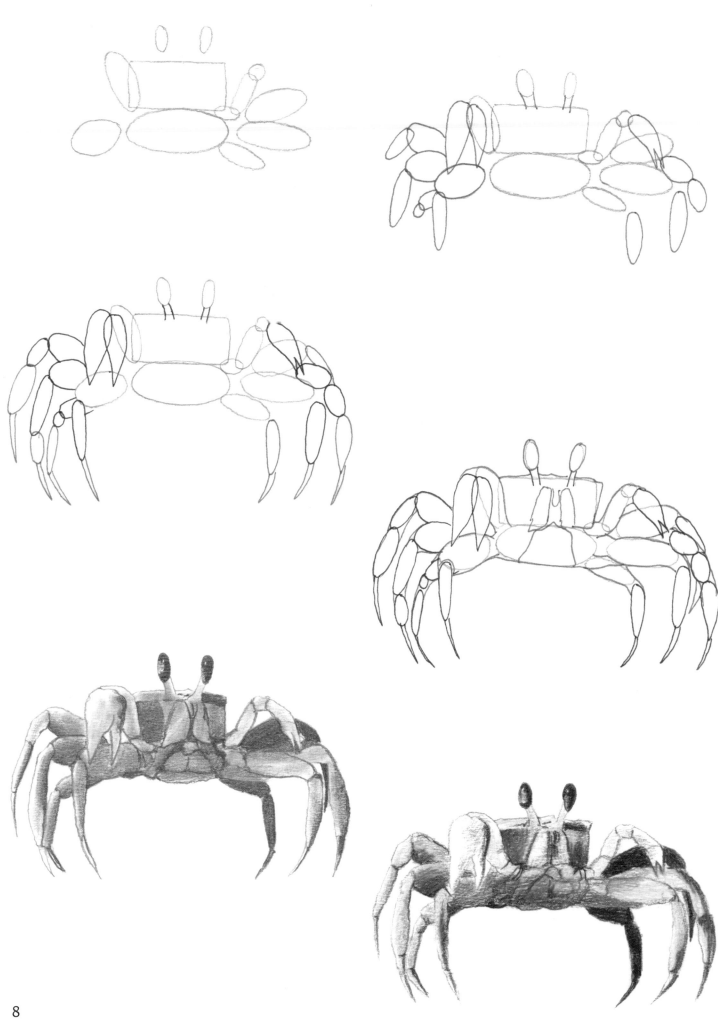

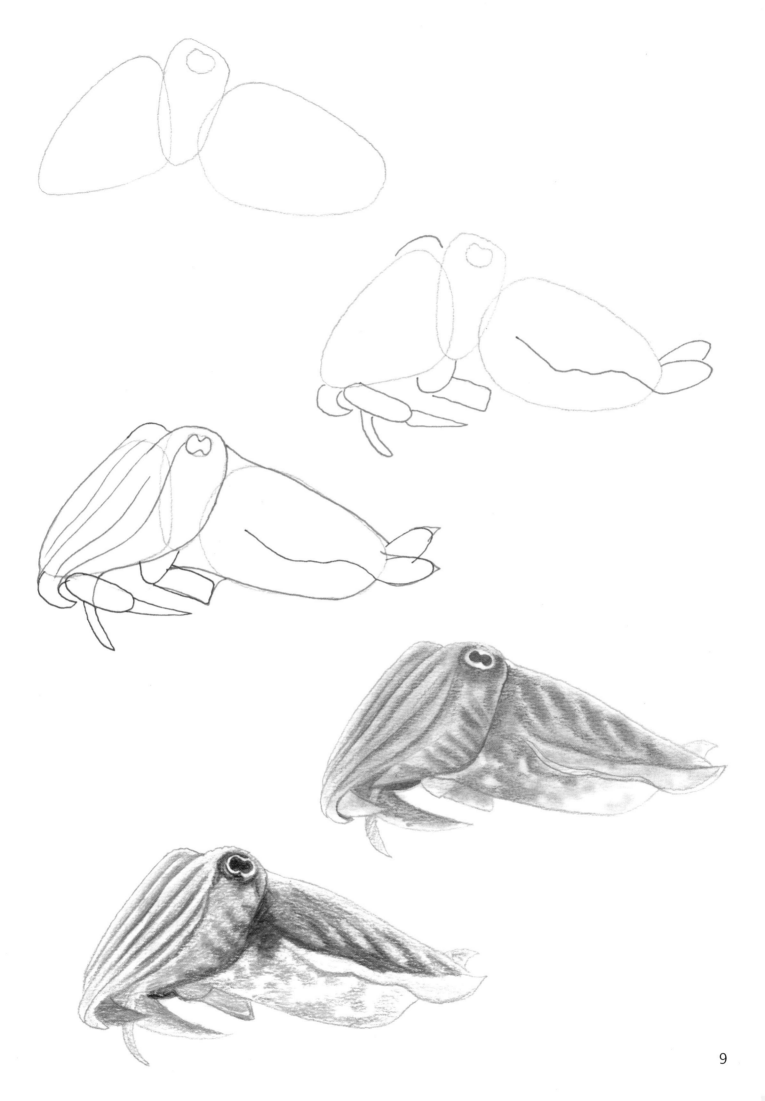

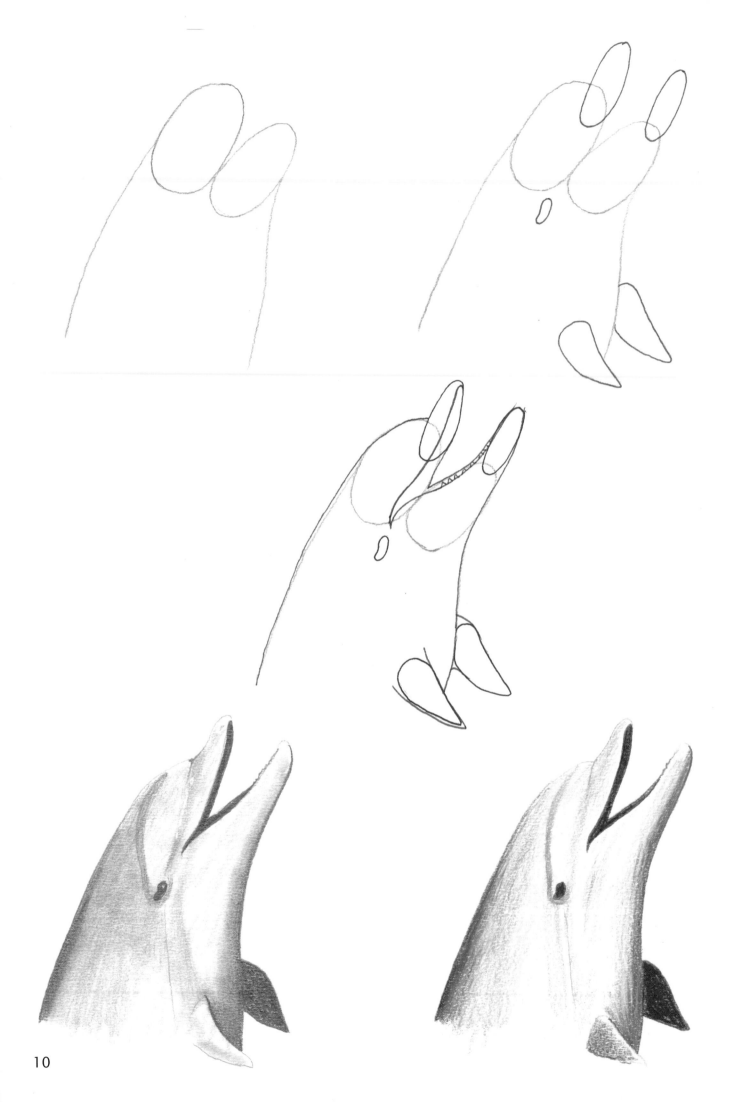

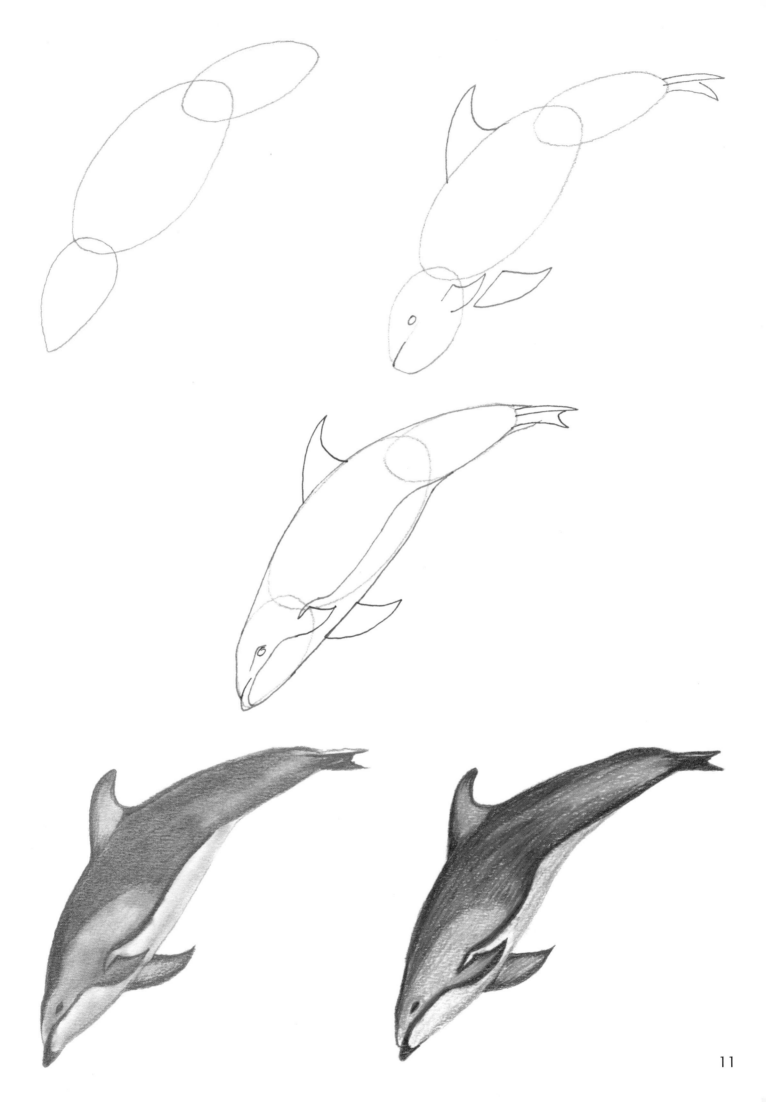

11

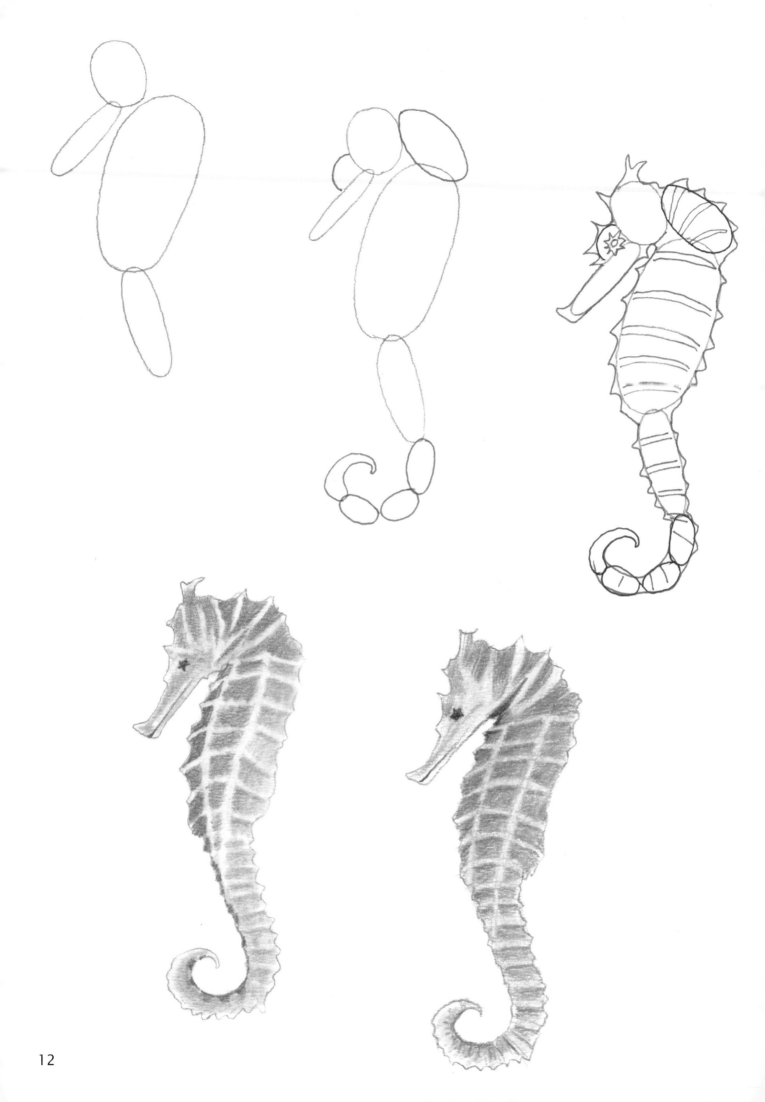

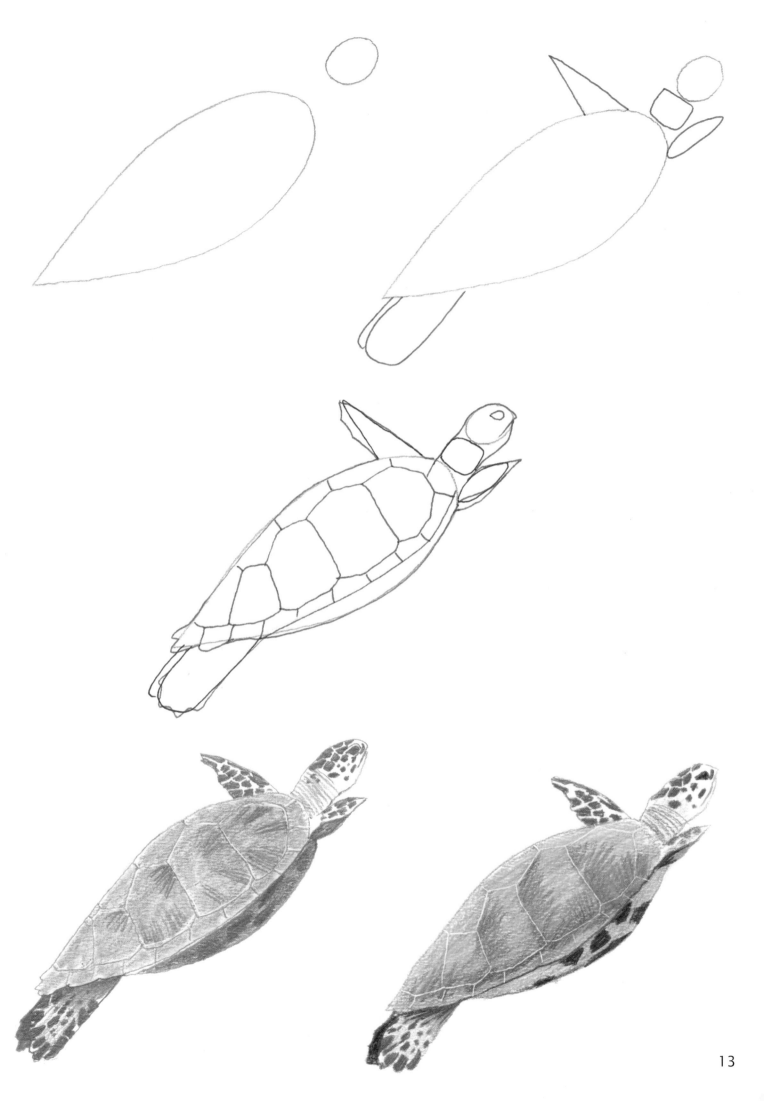

13

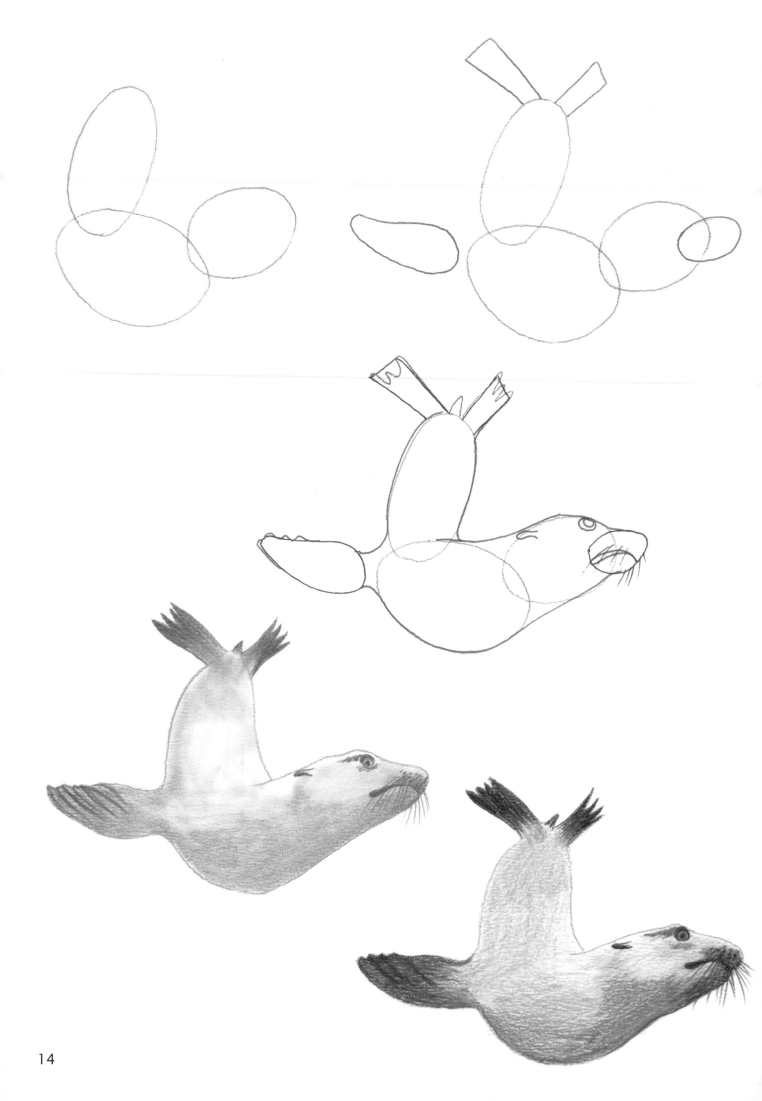

14

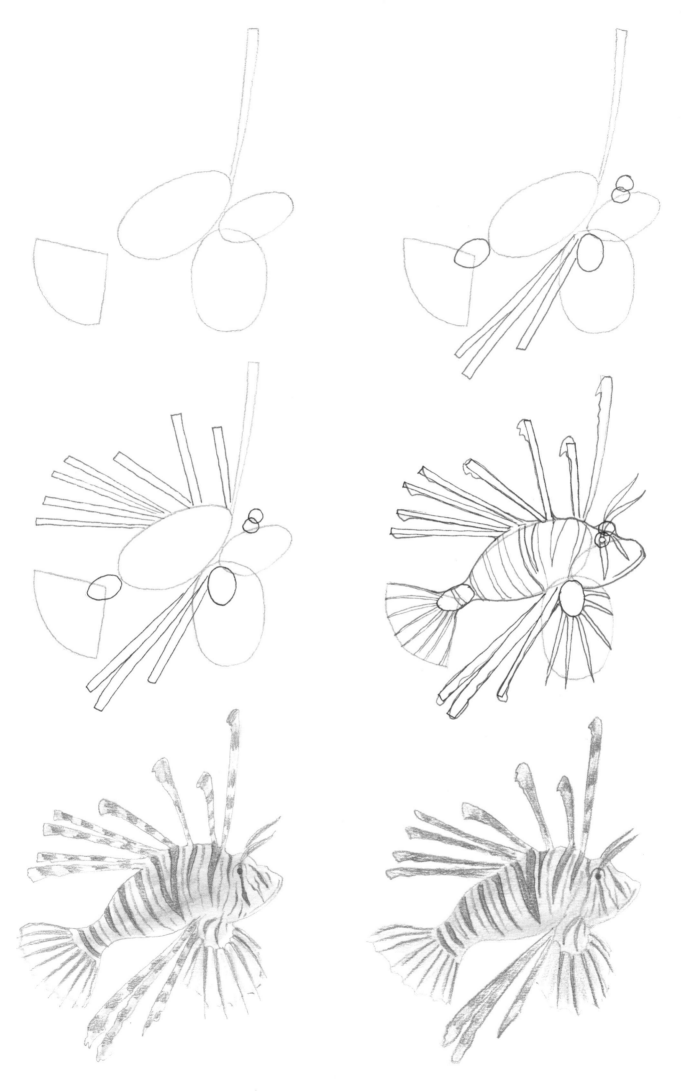

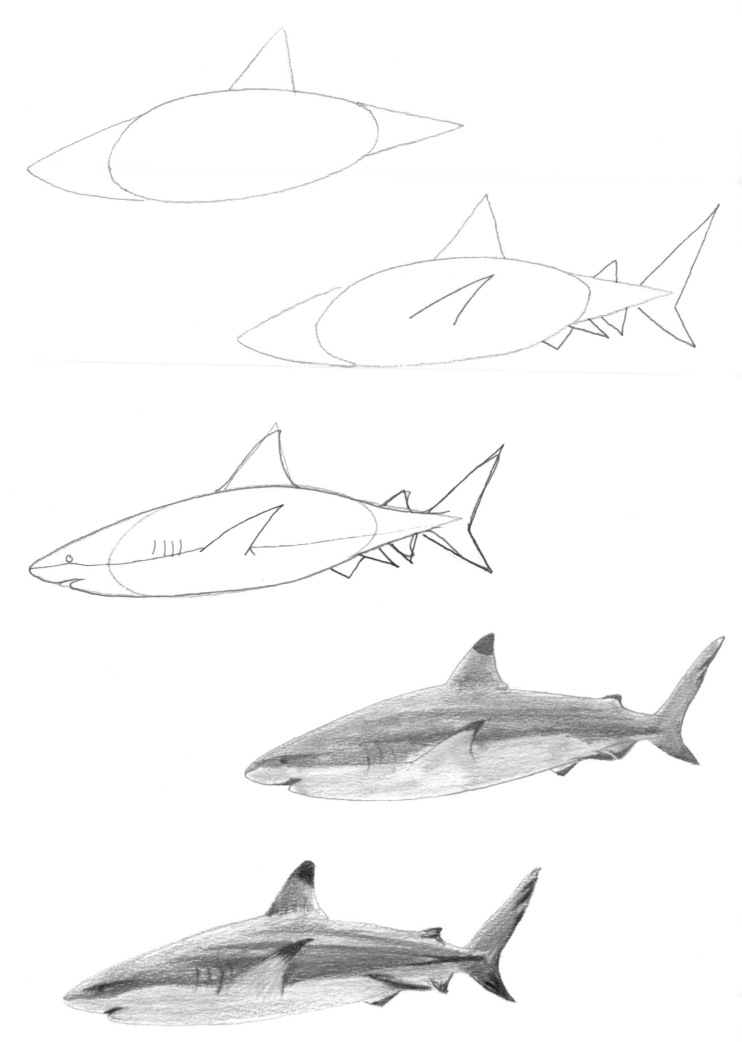

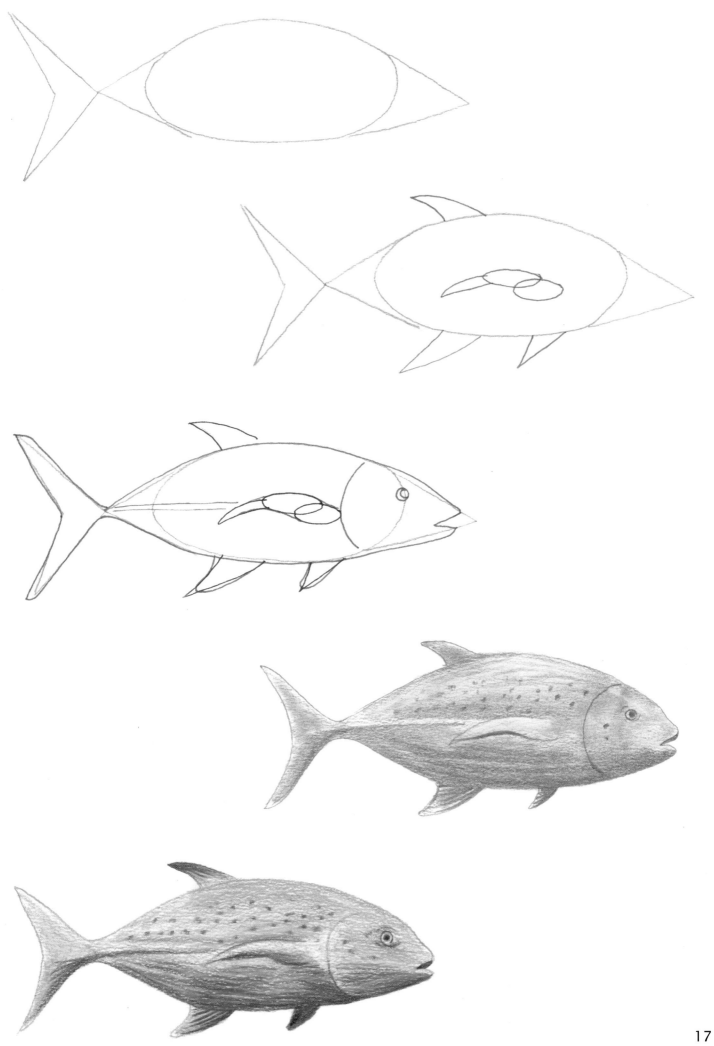

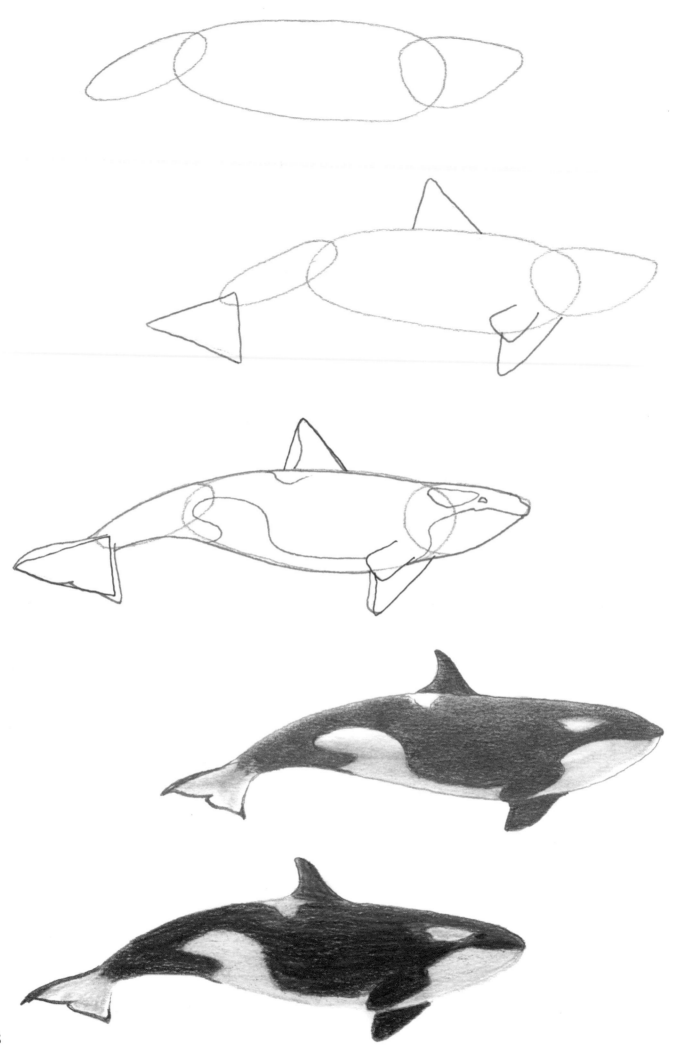

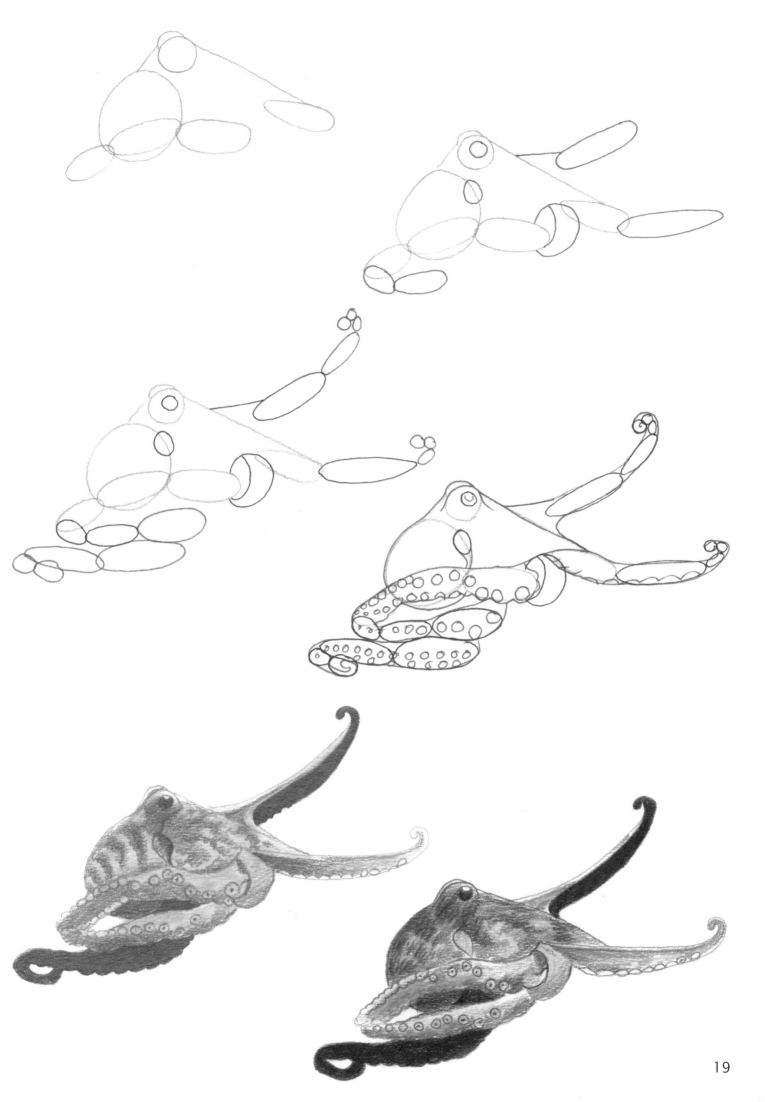

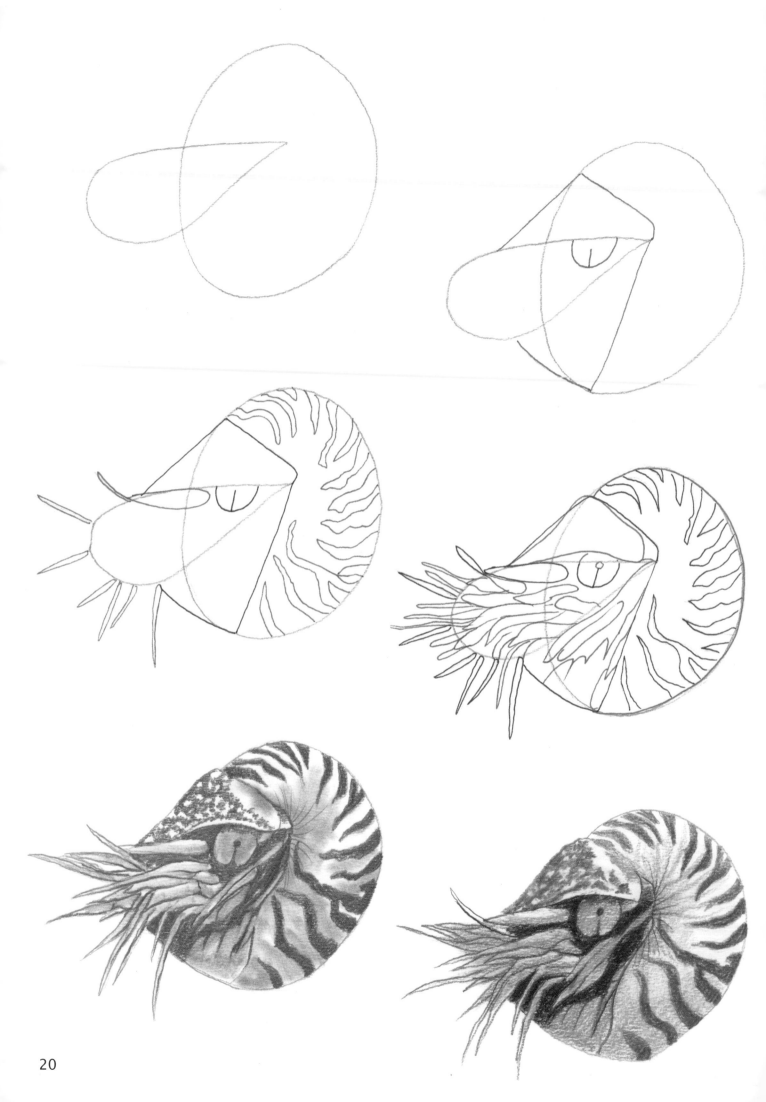

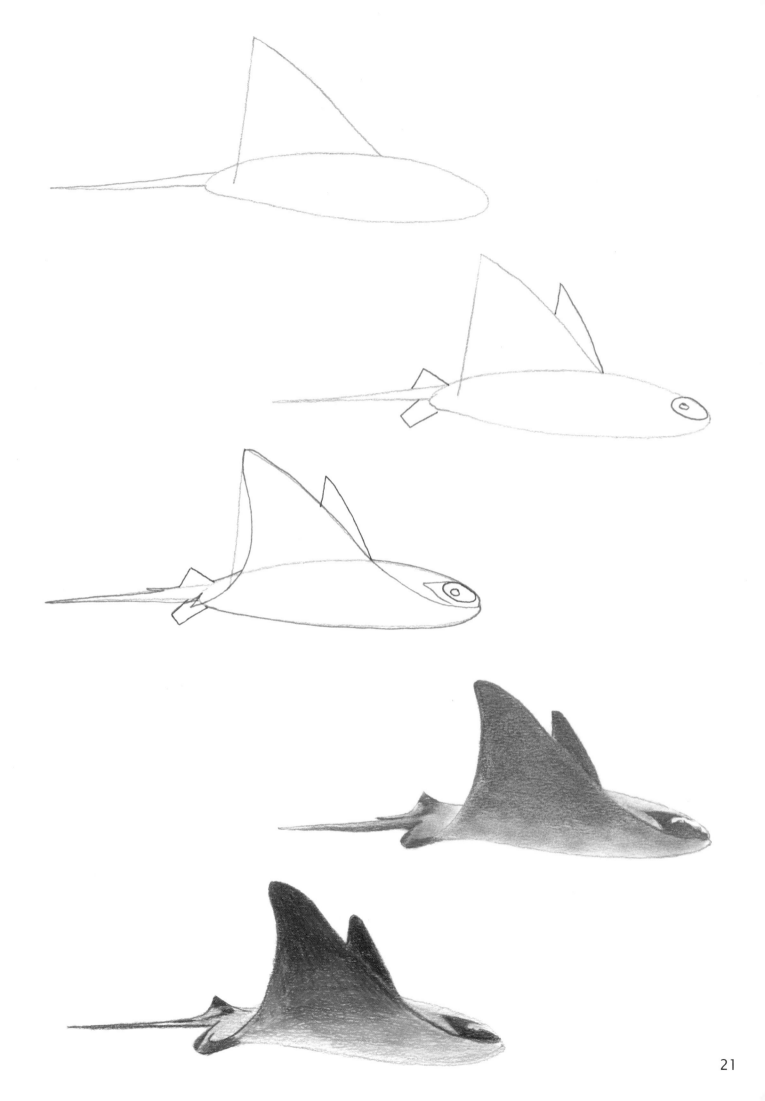

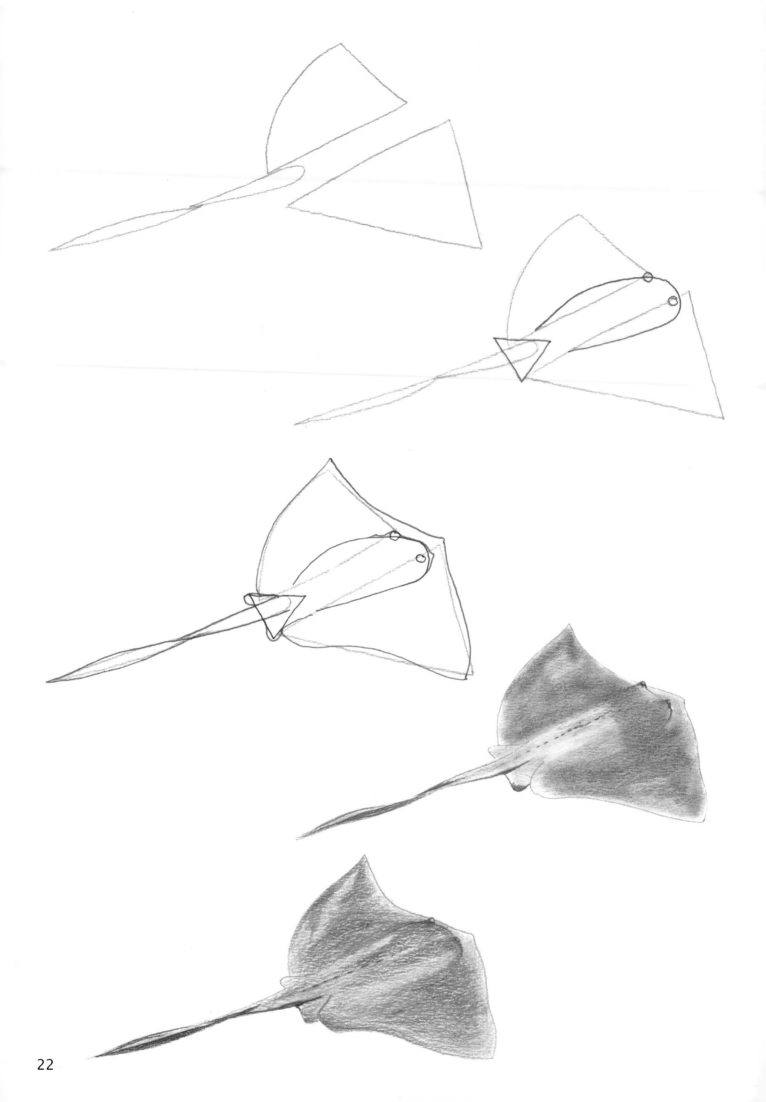

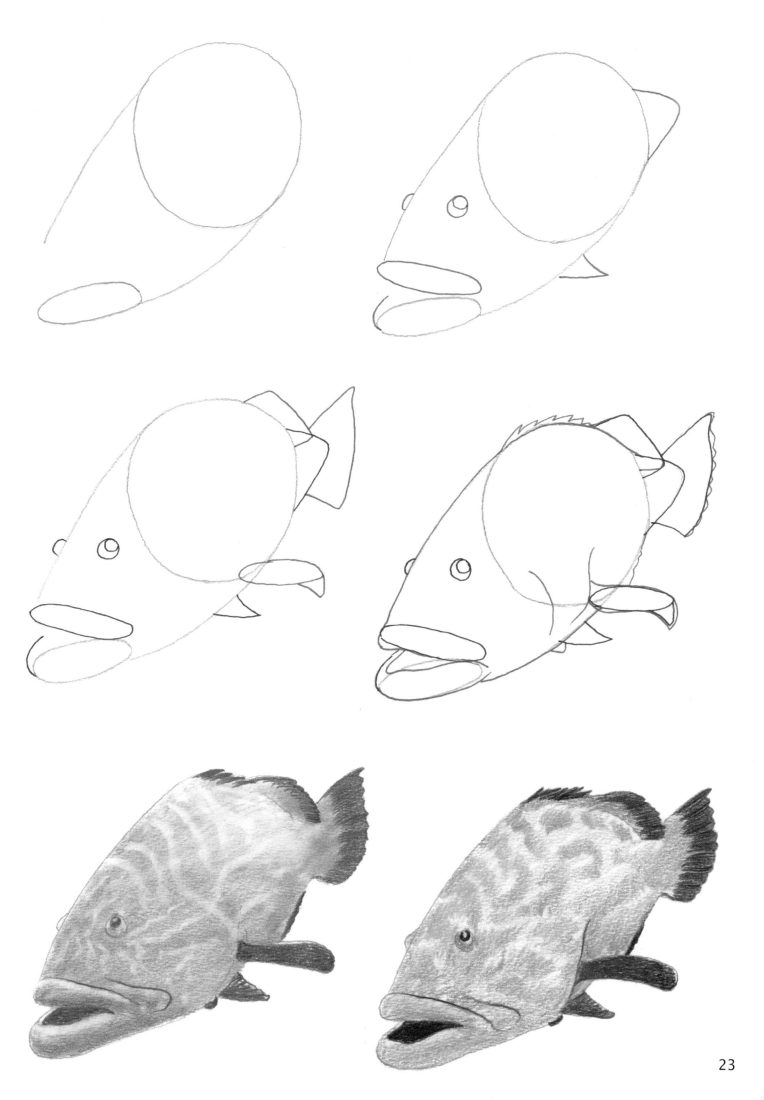

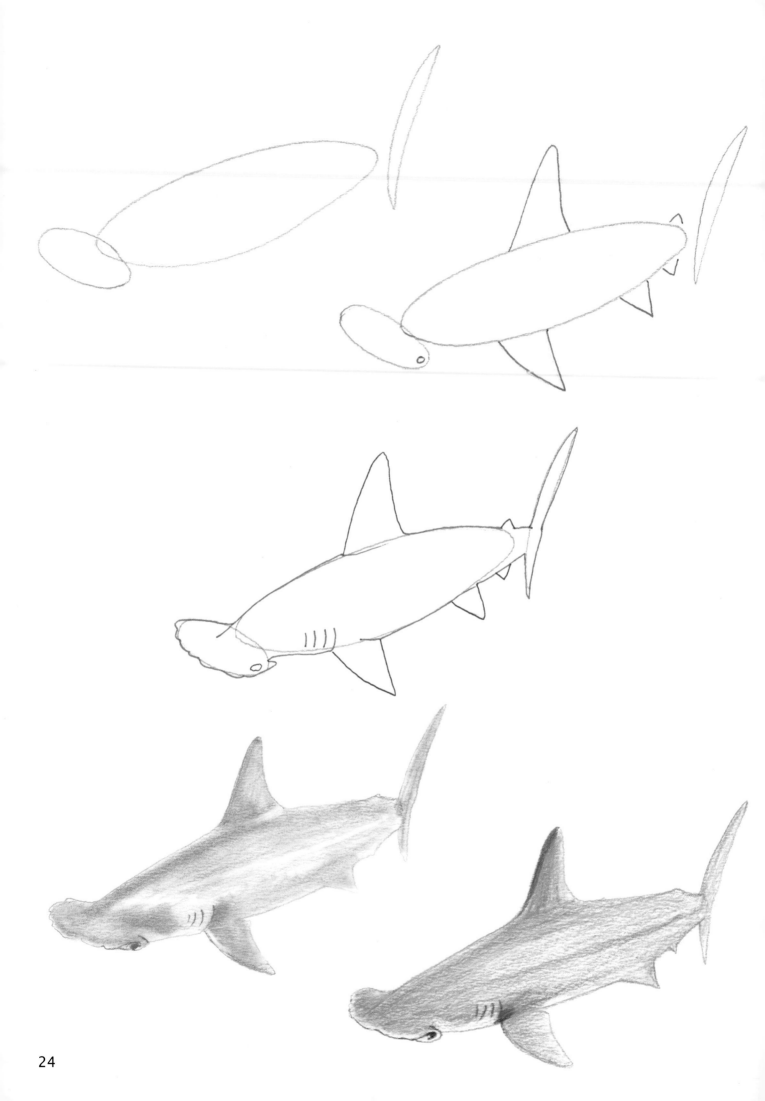

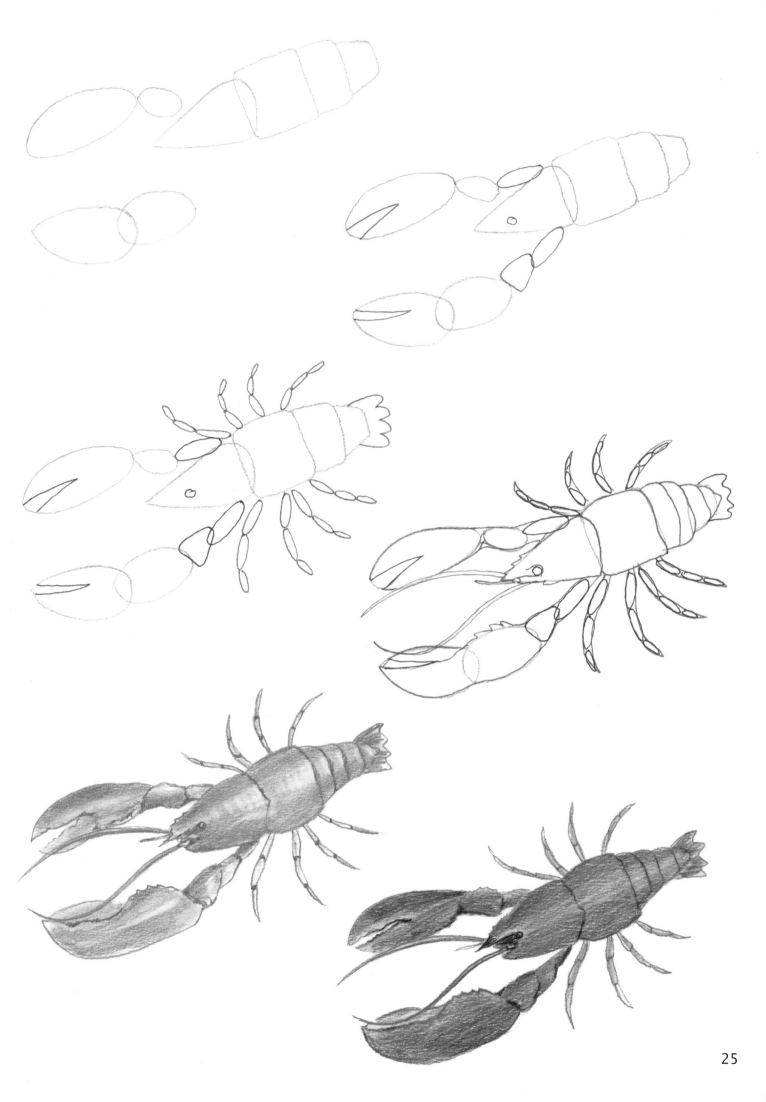

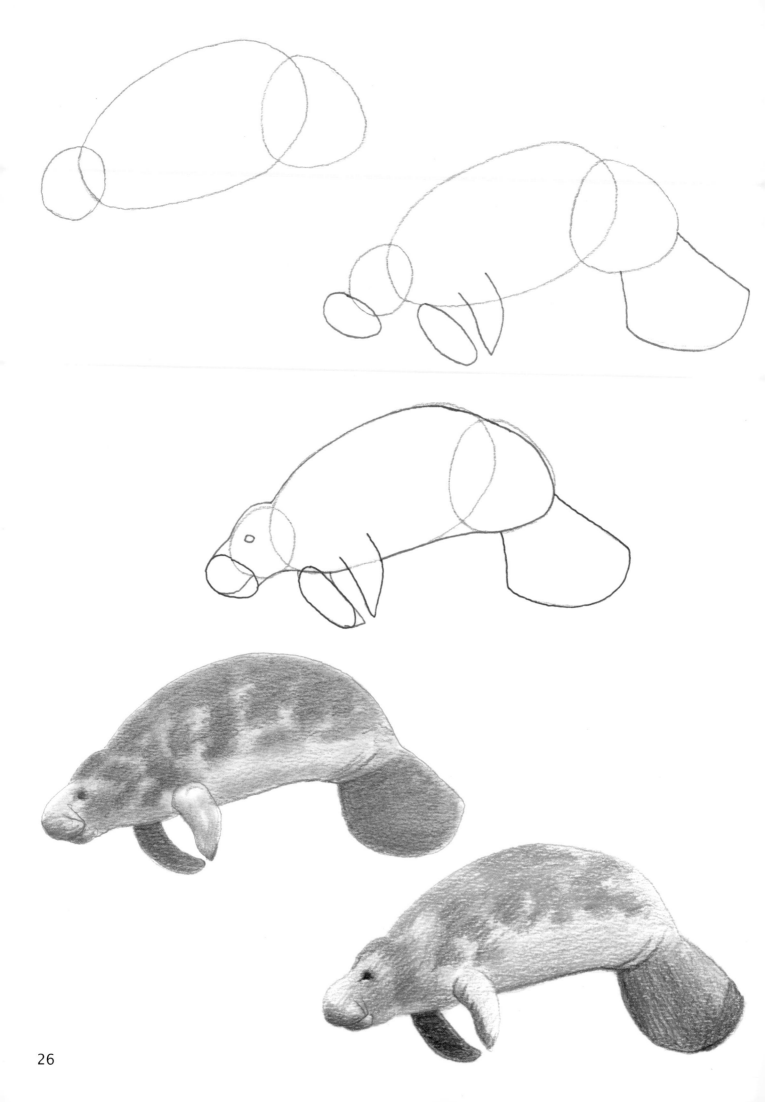

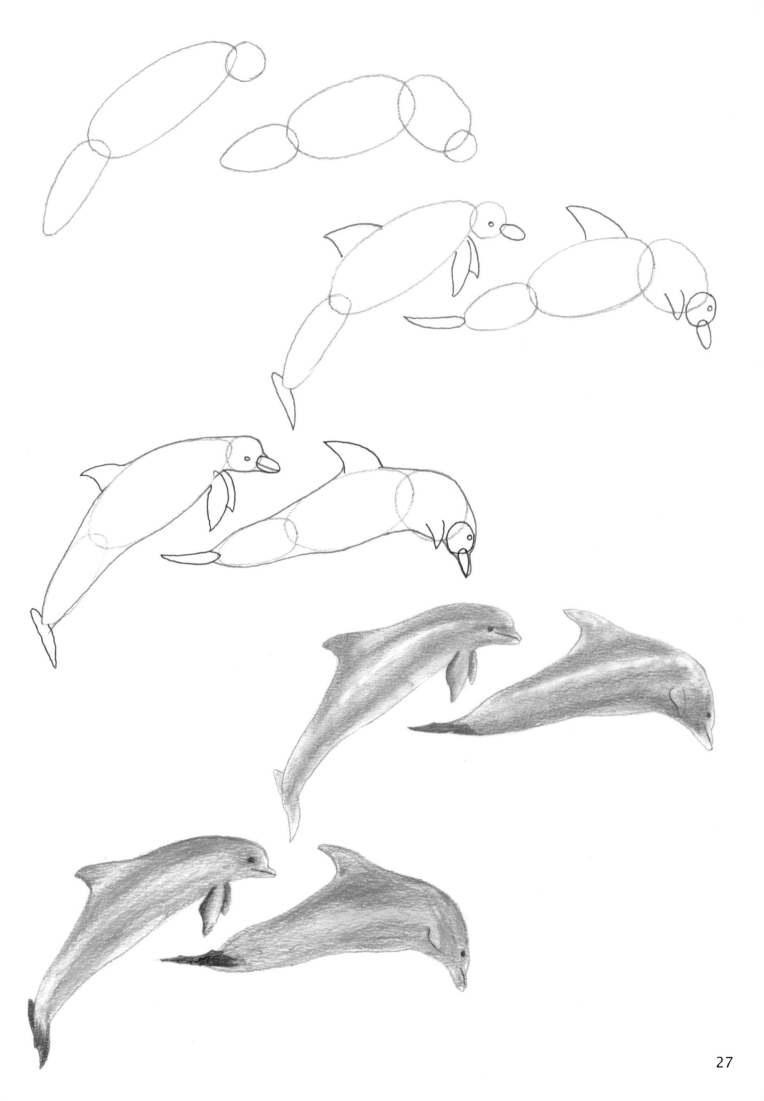

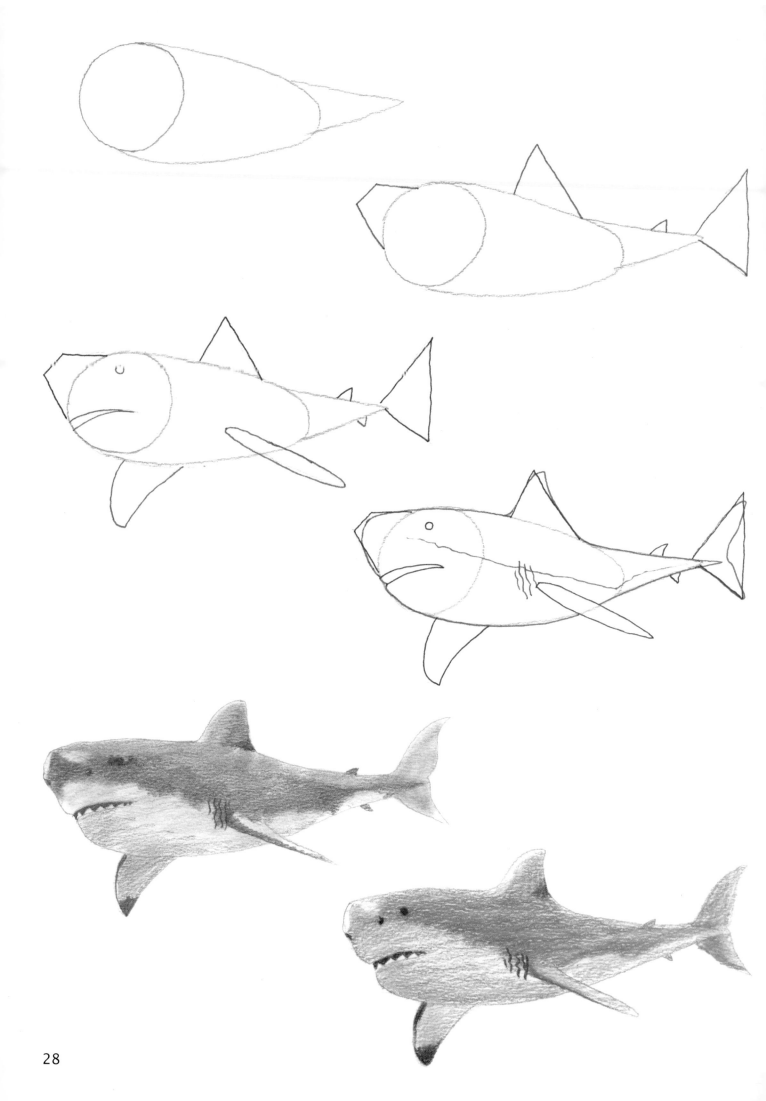

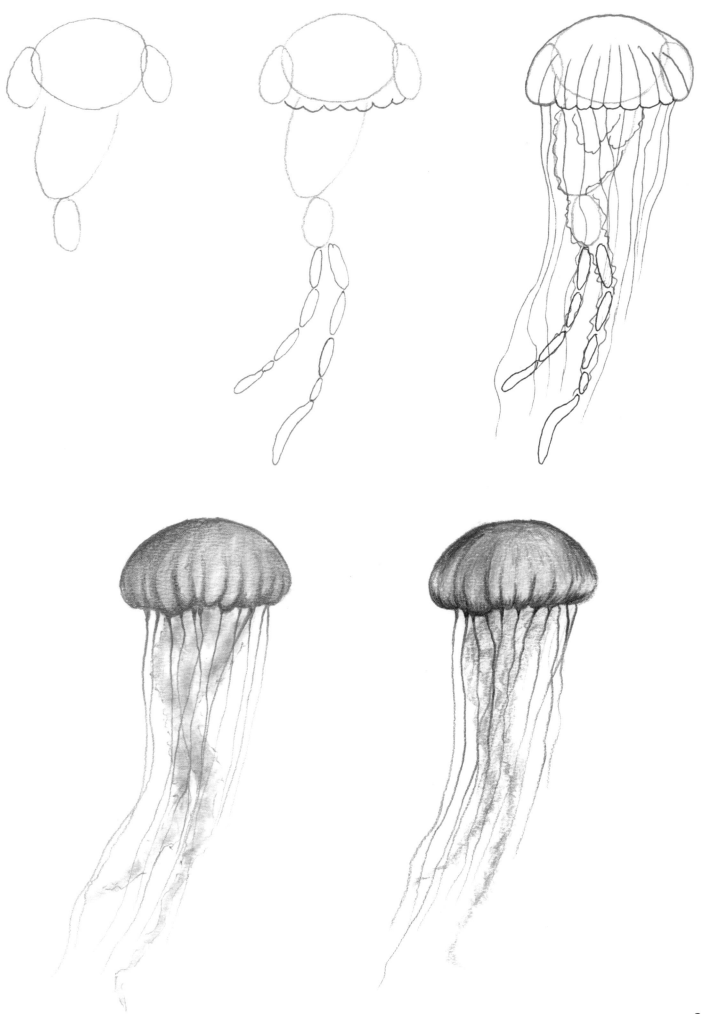

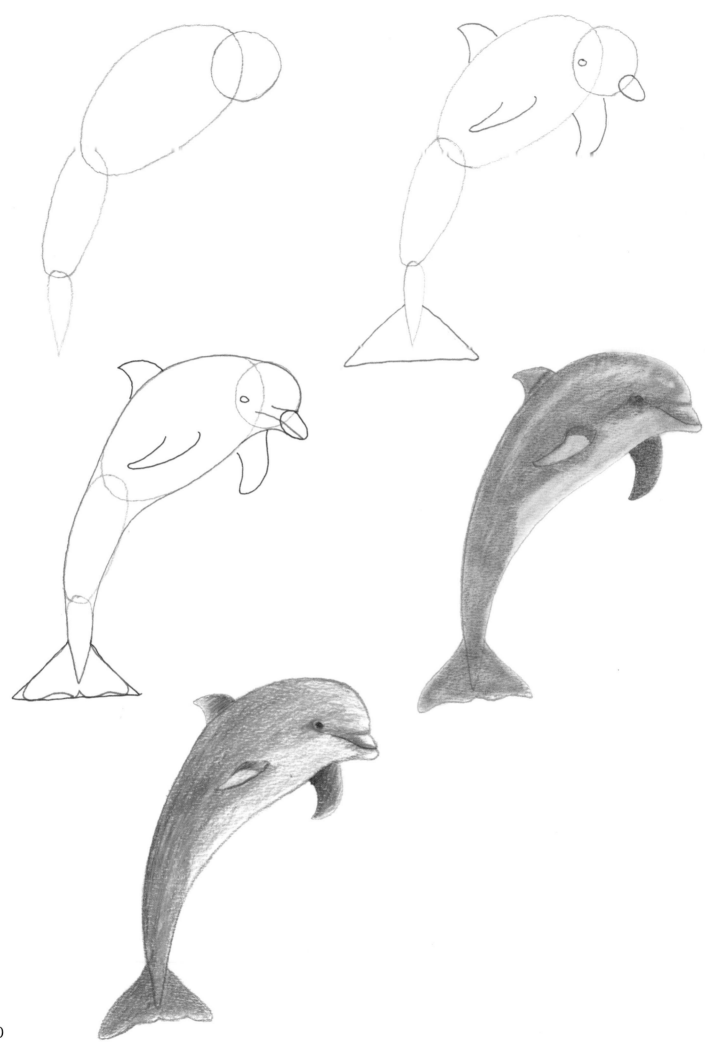

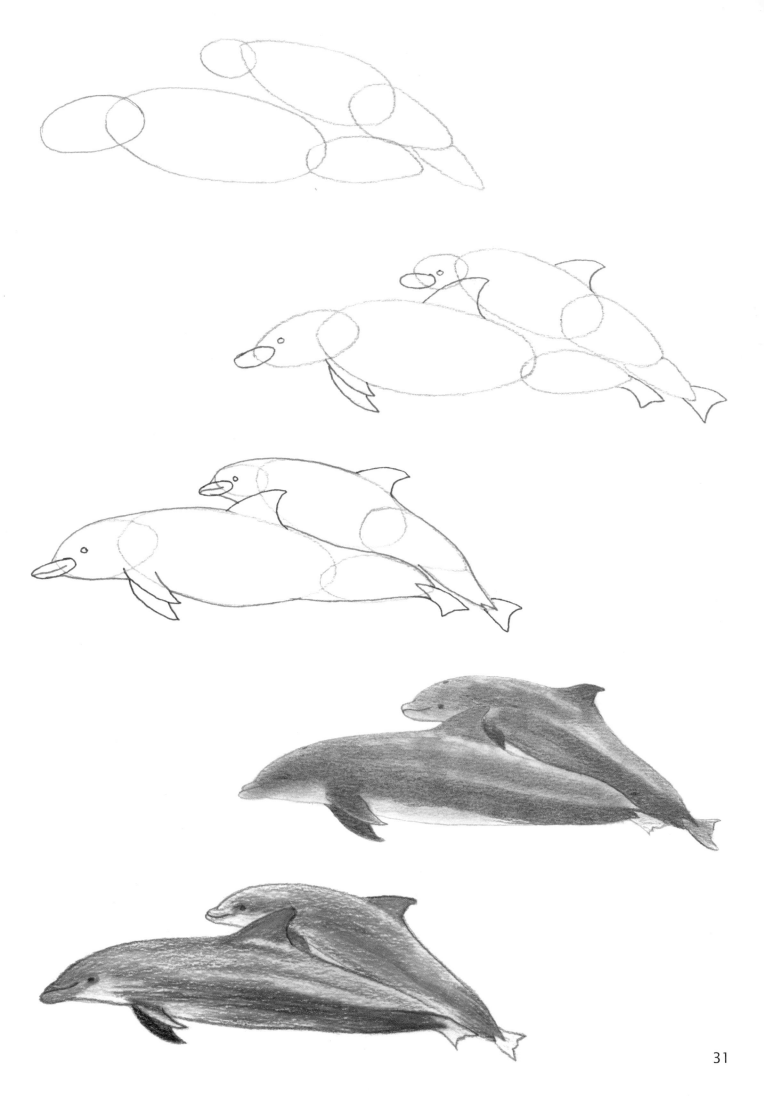

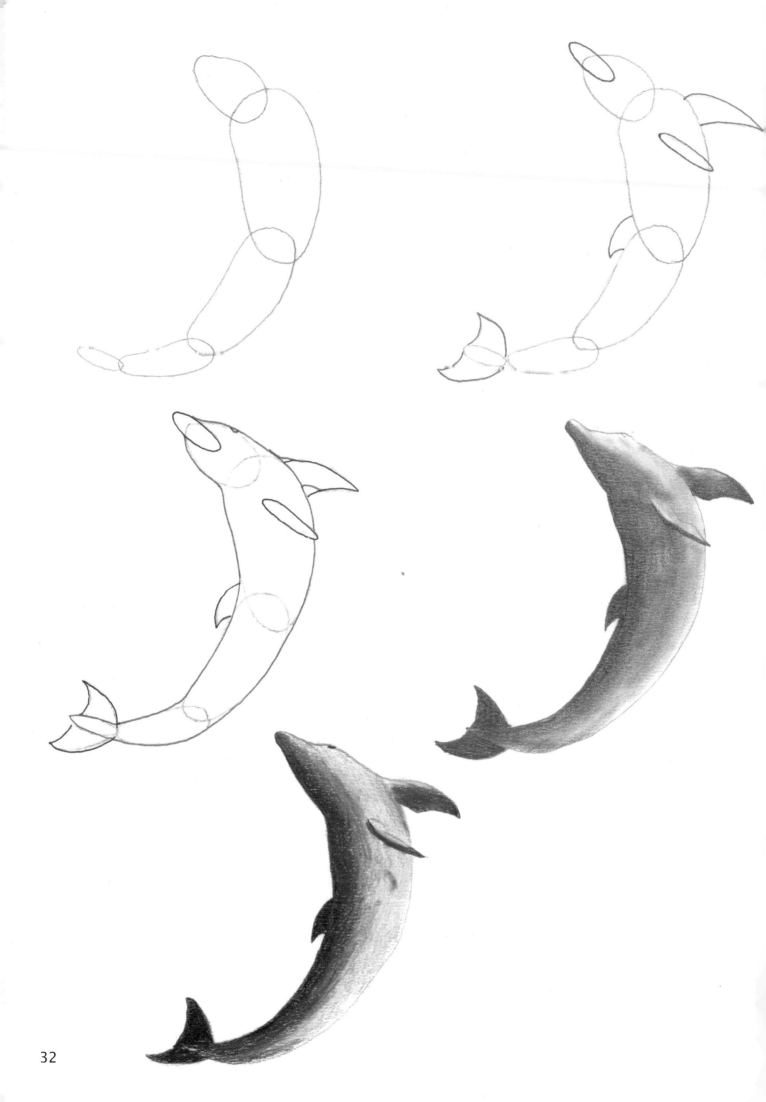